STRANGE DAYS
British Contemporary Photography

a cura di / edited by
Gilda Williams

Richard Billingham
Zarina Bhimji
Thomas Demand
Willie Doherty
Paul Graham
David Griffiths
Sarah Jones
Sarah Lucas
Wendy McMurdo
Steven Pippin
Stuart Smith
John Stezaker
Sam Taylor-Wood
Gillian Wearing
Catherine Yass

CHARTA

Progetto grafico / Design
Gabriele Nason

Coordinamento redazionale
Editorial coordination
Emanuela Belloni

Redazione / Editing
Elena Carotti

Traduzione / Translation
Elisa Massoni

Ufficio stampa / Press office
Silvia Palombi Arte & Mostre,
Milano

Realizzazione tecnica
Production
Amilcare Pizzi Arti grafiche,
Cinisello Balsamo, Milano

Copertina / Cover
Dal film *Gli Uccelli* di Alfred
Hitchcock / From *The Birds* by
Alfred Hitchcock
Copyright © 1997 by
Universal City Studios, Inc.
Courtesy of Universal Studios
Publishing Rights.
All Rights Reserved

Un particolare ringraziamento
alle Case editrici Nuova
Pratiche e Harper-Collins per
l'autorizzazione ad usare le
citazioni di Hitchcock tratte
dalle loro pubblicazioni.

Thanks are due to Harper
Collins and Nuova Pratiche
editrice for their kind
permission of using
Hitchcock's quotes from their
books.

© 1997
Edizioni Charta, Milano
© Claudia Gian Ferrari
Arte Contemporanea,
Milano
© Thomas Demand by SIAE,
1997

All Rights Reserved

ISBN 88-8158-138-8

Edizioni Charta
via Castelvetro, 9
20154 Milano
Tel. 39-2-33.60.13.43/6
Fax 39-2-33.60.15.24

Printed in Italy

Claudia Gian Ferrari
Arte Contemporanea
via Brera, 30
20121 Milano
Tel. 39-2-86.46.16.90
Fax 39-2-80.10.19

Strange Days
British Contemporary
Photography

Claudia Gian Ferrari Arte
Contemporanea

Milano
18 settembre - 8 novembre 1997
September 18 - November 8, 1997

Con il contributo di
With the contribution of

The British Council

Si ringraziano
Thanks are due to

The British Council, London;
Brendan Griggs, The British
Council, Roma; Iwona
Blazwick, London; Tommaso
Corvi-Mora, London; Alison
Jacques, Roma; Elisa Massoni,
Milano; Clare Stent, London;
Sadie Coles HQ, London;
Galleria Massimo De Carlo,
Milano; Laurent Delaye
Gallery, London; Galleria Emi
Fontana, Milano; Laure
Genillard Gallery, London;
Lotte Hammer Gallery,
London; Victoria Miro Gallery,
London; Maureen Paley/
Interim Art, London; Jay
Jopling/White Cube, London;
Anthony Reynolds Gallery,
London;
un particolare ringraziamento
a tutti gli artisti/ special
thanks to all the artists

Sommario/Contents

Gilda Williams

Picture This: Strange Days

C'è stato un tempo, fino all'inizio degli anni Sessanta, in cui ci si riferiva a un film marginalmente, come a un'"immagine" (nella lingua inglese il sostantivo ha un doppio significato: "picture"/immagine, "picture"/film), proprio come se si volesse isolare un fermo immagine universale, colto dall'insieme di fotogrammi che formano il progetto più grande del film.

The Picture: singolo e irriducibile. È un termine coniato a Hollywood, dove i film erano solo delle sequenze di immagini e difficilmente una forma d'arte.

All'opposto, il film artistico (come si insisteva a chiamarlo) lottò a lungo e duramente per guadagnarsi una posizione culturalmente elevata, distinguendosi deliberatamente dal film hollywoodiano grazie all'adozione di una serie di convenzioni, come l'uso del bianco e nero o il rifiuto per le grandi "star" americane, e così via. Fra i pochi registi dell'epoca del Film Hollywoodiano che hanno saputo superare il divario fra arte e cultura di massa c'è Alfred Hitchcock, ibrido anglo-europeo che seppe tenere il grande pubblico attaccato alla poltrona dei cinema con i suoi film visivamente provocatori e pesantemente analitici. Anche la fotografia artistica ha dovuto lottare da sempre contro i suoi "cugini poveri" – l'istantanea, il reportage, la cartolina – per difendere il proprio ruolo fra le belle arti.

In ogni caso, sia la fotografia artistica sia i registi di Hollywood si irrigidirono nel fornire un'immagine, anzi "L'Immagine", *The Picture*: la somma e il *climax* dell'evento, il momento in cui il messaggio è visualmente più completo all'interno delle limitazioni specificatamente spaziali e temporali di un singolo fotogramma. Curiosamente si pretendeva dalla fotografia d'alto livello e dai film hollywoodiani questo tipo di momento sintetico, mentre il film d'essai poteva scorrere senza avvenimenti di rilievo, in modo non dissimile da come ci si aspetta la comune istantanea, ovvero dispersiva, idiosincretica e potenzialmente banale.

Questo tipo di distinzioni circa la cultura di alto e basso livello è diventato insignificante da qualche tempo a questa parte. Alla fine del Ventesimo secolo la fotografia come espressione artistica è un dato di fatto, e questo ha avuto un

Gilda Williams

Picture This: Strange Days

There was a time, up until the early 1960s, when a movie was broadly referred to as 'a Picture', as if accentuating the overall still image that could be culled from the series of innumerable frames which make up the larger project of the movie. The Picture: singular and irreducible. It's a term rooted in Hollywood, where movies were hardly an art form; a film was just a sequence of pictures. In contrast, the art film (as it insisted on being called) struggled long and hard to gain any 'high culture' standing, and distinguished itself very deliberately from the Hollywood 'picture' by adopting a series of conventions, such as its black and white film stock, its avoidance of big American stars, and so forth. Among the few directors in the age of the Hollywood Picture to overcome the alleged distinction between art and mass culture divisions was Alfred Hitchcock, a kind of Anglo-European hybrid whose visually provocative, boldly analytical films also kept mainstream audiences on the edge of their seats.

Art photography, too, has traditionally had to fight off its lesser cousins – the snapshot, photo-reportage, the picture postcard – to maintain its precarious position amongst the fine arts. Much art photography did, like the average Hollywood film, set out to make a picture, indeed to provide *the* Picture: the summation and climax of the event, the moment the message is most visually complete, within the very specific temporal and spatial limitations of an individual shot. This kind of synthetic moment was curiously expected of high photography and of Hollywood pictures, while art films could ramble along uneventfully, not unlike the way common photography is expected to be quirky, idiosyncratic and potentially dull.

These kinds of distinctions between 'high' and 'low' visual culture, have been gradually blurring into insignificance. Photography as an art form is a *given* at the end of the twentieth century, and this has had an enormously liberating effect on its practitioners. The photo-based work currently being produced in England, Scotland and Ireland, the subject of the exhibition 'Strange Days', is consequently

effetto enormemente liberatorio. Il tema di questa mostra, dedicata al lavoro fotografico prodotto in Inghilterra, Scozia e Irlanda, non riguarda l'assunzione del Mezzo Eletto (la fotografia) nell'empireo dell'Arte. Infatti non ci sono imposizioni auto-qualificanti: non si accentuano le valenze tecniche, non viene creata una narrazione coerente che lega la fotografia a una sorta di concentrata letteratura grafica, e tanto meno si sostiene una distanza formale dall'istantanea di tutti i giorni. Il confine con la fotografia ordinaria è ciò che la maggior parte (anche se non tutti) degli artisti di *Strange Days* ricerca realmente. Come in Hitchcock, l'uso comune della fotografia nel documentare il mondo quotidiano viene sfruttato per esaltare la stranezza degli eventi descritti. Raggiungere "L'Immagine", l'essenza delle circostanze reali, non è più l'imperativo della fotografia artistica, che può quindi sperimentare oltre, trovando inconsapevolmente fonte d'ispirazione nella psicoanalisi, nell'immaginario politico, nella pubblicità, nell'autobiografia e nelle forme artistiche tradizionali. Questo tipo di fotografia può ispirarsi al film, può persino prendere prestiti dal "picture" hollywoodiano. Comune a tutti gli artisti presentati in questa mostra è la confidenza con cui la macchina fotografica, l'immagine stampata, la camera oscura, il negativo e, a volte, l'immagine digitale, vengono scelte e usate per produrre la propria arte. Alfred Hitchcock aveva lo stesso tipo di confidenza nel mezzo prescelto, il cinema. Non sembra essersi mai chiesto se stesse producendo arte o no. Ignorando il divario fra film artistico e cinema, il suo lavoro è stato influenzato dalla pittura degli antichi maestri così come dai romanzi "gialli" e dalla narrativa "da quattro soldi". È forse per questa ragione che gli imperativi di Hollywood e le aspettative del cinema artistico europeo sono più compattamente risolte e sovrapposte in Alfred Hitchcock. Per lui il cinema come forma d'arte era cosa scontata, dunque gli fu possibile inventare in modo convincente enormi e complicate metafore, come ne *Gli Uccelli*, senza cadere nella bizzarria fiabesca. I film di Hitchcock, come il lavoro di questi artisti, si svolgono sempre durante giorni strani in cui le cose cominciano normalmente e finiscono con l'essere indimenticabili.

Alfred Hitchcock: *Non avrei girato il film [*Gli Uccelli*] se si fosse trattato di avvoltoi o di uccelli da preda; quello che mi è piaciuto è che si trattava di uccelli comuni, di uccelli di tutti i giorni.* [1]

L'ordinario è distorto e ripresentato nel lavoro di Thomas Demand, artista di origine tedesca diplomatosi alla London's

unconcerned with heightening its chosen media to the art realm. There are no impositions of qualifying itself, either by accentuating its technical worth, or creating a coherent narrative which likens the photograph to a condensed sort of graphic literature; or sustaining a formal distance from the ordinary snapshot. The edginess of ordinary home photography is often the very quality many of the artists in 'Strange Days' are actually after. Like with Hitchcock, the photograph's common use in documenting the everyday world is exploited to enhance the strangeness of the events depicted.

Achieving The Picture, the essence of real circumstances, is no longer the imperative of photo-based art, and so it can experiment laterally, borrowing unself-consciously from psychoanalysis, from political imagery, advertising, autobiography, and from traditional art forms of sculpture and painting. It can borrow from film, it can even borrow from the movie picture. Common to all the artists presented in this exhibition is the confidence with which the camera or the found image are taken into hand and, in some caases, the skill with which the darkroom, the negative and, at times, the digital-image computer is chosen and handled in making their art.

Alfred Hitchcock had this same kind of confidence in his selected media, filmmaking. He never seemed to question whether or not he was producing art. Unconcerned with the art-film/movie-picture split, his work was as influenced by Old Master painting as it was by the dime-novel and cheap thrillers. Perhaps for this reason the imperatives of Hollywood and the expectations of Euro-art films are most compactly resolved and overlapped in Alfred Hitchcock. Film as an art form, for Hitchcock, was a given, and thus he could convincingly shoot complicated, giant metaphors, as in *The Birds*, without it lapsing into a kind of bizarre fable. Hitchcock's films, like the work of these artists, always occur on strange days, when things begin ordinarily, and end up unforgettable.

Alfred Hitchcock: *I think if the story (of* The Birds*) had involved vultures, or birds of prey, I might not have wanted it. The basic appeal for me is that it had to do with ordinary, everyday birds.*[1]

The ordinary is distorted and re-presented in the work of German-born, sometimes-British-based artist Thomas Demand, a graduate of London's Goldsmiths' MA course. Ordinary scenes of a desktop, or an anonymous architectural

Goldsmith's MA, che di tanto in tanto vive e lavora in Gran Bretagna. Scene comuni da una scrivania o anonime vedute architettoniche sono ricreate e messe in scena, come se Demand stesse confessando la potenzialità illusoria della fotografia. Guardate nuovamente il mondo di Demand: la luce è innaturale, gli oggetti sono in posa, lo scenario è una ricostruzione manipolata del quotidiano. In breve: i paesaggi di Demand sono poco credibili, sono messe in scena della realtà che tolgono familiarità al quotidiano per farci guardare ogni cosa più attentamente.

La sua strategia è opposta a quella di Stuart Smith, il cui mondo comune si rivela come una palude di realtà sovrapposte. Smith è un poeta che accompagna le sue immagini volutamente surreali con parole leggermente incongrue, intime in modo emozionante. Le sue foto sono state scattate durante alcuni viaggi negli Stati Uniti; la sua attenzione, più che essere catturata dalla vastità di questi nuovi paesaggi, si circoscrive, si leviga sui dettagli di una sala d'attesa, di un'area di sosta, del comodino di un albergo. Con Smith, l'immagine è apparentemente artificiale eppure è ciò che viene comunemente definita una "presa diretta": non manipolata, ma impressionante nel suo effetto. Demand e Smith formano il braccio portante, se vogliamo, di *Strange Days*: le prime immagini volutamente riconoscibili che conducono con l'inganno ad abbandonare il proprio mondo eccessivamente familiare e ad elevare scene che potrebbero facilmente essere ignorate fino a farle diventare visioni forti e allucinatorie. Loro mettono in discussione la nostra idea della fotografia che, in primo luogo, dovrebbe dire la verità e, in secondo luogo, dovrebbe catturare il singolo momento sigificativo. Sia Demand che Smith rifiutano deliberatamente di rispettare questi due assunti.

A.H.: *Negli* Uccelli (The Birds) *ho fatto in modo che il pubblico non possa mai indovinare quale sarà la scena successiva.*

La valenza profetica della fotografia è stata sfruttata, reiterata e negata lungo tutta la breve storia di centocinquant'anni. Per funzionare così misteriosamente e così bene, le immagini di Griffiths fanno leva sulle nostre aspettative e sulla nostra incomprensione. Le foto sono scattate di notte, fuori dall'Houses of Parliament; appena la sessione si aggiorna, Griffiths aspetta che i reporter e i membri del governo emergano dall'oscurità, per rispondere con la telecamera nascosta e storicizzare gli accadimenti del giorno. L'evento qui non è ciò che è registrato dalla televisione, non

view, are staged and recreated in his photographs, as if Demand were sort of confessing photography's potential for deceit. Look again at Demand's world: the light is unnatural, the objects are posed, the scene is a manipulated reconstruction of the everyday. In short, Demand's images are hardly to be trusted; theatricalizations of the ordinary, they defamiliarize us with the commonplace to make us watch more carefully.

His strategy is opposite to that of Stuart Smith, whose ordinary world suddenly reveals itself as a quagmire of overlapping realities. Smith is a poet who accompanies his wilfully surreal pictures with somewhat incongruous, touchingly personal texts. These pictures were taken during his travels in the United States; rather than mesmerized by the vastness of this new landscape, his attention seemed in contrast to grow more finite, honing in on the details of a waiting room, a truck stop, a hotel bedside table. With Smith, the picture has the appearance of artifice and yet is what has traditionally been called 'straight photography': unmanipulated, yet startling in its effect. Demand and Smith form the brackets, if you will, of 'Strange Days': the first orchestrating ordinary images to illude the viewer into dismissing its over-familiarity, the second in elevating scenes that would easily be ignored into visionary, powerful moments. They question our very expectations of what photography does: first, to tell the truth; second, to capture singular, 'significant' moments. Both Demand and Smith very deliberately refuse to fulfil either of these two assumptions.

A.H.: *With* The Birds, *I made sure the public would not be able to anticipate from one scene to another.*

Predictability in photography has been abused, reiterated, and denied throughout its brief, 150-year history. David Griffiths' pictures depend on our expectations – and incomprehension – in order to function as mysteriously, and as well, as they do. The pictures are taken by night outside of the Houses of Parliament; as the sessions adjourn, Griffiths waits for the members of government or reporters to emerge from out of the darkness, to play to the waiting television camera and historicize the day's goings-on. The event here is not what is recorded on television, not the familiar, frontal scene; the event is the newscasting itself, seen unnaturally from the side, without the glare of TV lighting but only slivers of light describing an entire human being. And what of Griffiths himself, a lone figure in the dark, aiming, waiting, like some kind of voyeuristic citizen, a criminal or

la scena frontale, familiare; l'evento è la notizia stessa, vista innaturalmente di lato, senza il riverbero della luce televisiva ma solo attraverso frammenti di luce che descrivono un intero essere umano. Griffiths stesso è una figura solitaria nel buio, che ambisce, aspetta, nascosto dall'oscurità come un *voyeur*, un assassino politico o un criminale. L'evento qui è la spettacolarizzazione della storia politica, il processo di creazione della storia ufficiale. Le figure centrali, parlanti, sono simili a Dio; i margini sono più spettrali. Queste non sono fotografie costruite, ma quasi incredibilmente, sono immagini da "candid camera", dirette. I ritratti di Griffiths sono, in verità, del tutto non ufficiali.

L'artista scozzese Wendy McMurdo si appropria delle nostre identità – per ciascuno di noi assolutamente singole e irripetibili – e le inverte manipolandole digitalmente per farne dei doppi, tripli e quintupli dell'originale. Lo specifico dell'identità nel ritratto fotografico si trasforma in un compendio di possibili Io, in una serie di inverosimili doppi che fanno le veci di un'unica personalità. Come nella visione pluralistica dei quadri cubisti, le sue immagini *doppelgänger* offrono dei ritratti multipli e contraddittori, ingannevoli e ostentati. Sembrano gemelli ma non lo sono; è piuttosto la grande fantasia di incontrare sé stessi, di vedere l'Io non dall'interno, ma da un qualche altro posto più sicuro.

A.H.: *Ora ci sono certamente delle sfumature [ne* Gli uccelli*] che resteranno inosservate, ma sono assolutamente necessarie perché arricchiscono l'insieme e gli danno più forza.*

Nella serie di Gillian Wearing, *Signs that say what you want them to say and not signs that say what someone else wants you to say,* è offerta la possibilità a centinaia di passanti casuali di esprimere cosa hanno in mente, scrivendo delle parole che desiderano ardentemente dire. Blandi o penetranti, questi messaggi sono più visuali che letterari, incorniciati dalle attente limitazioni formali dell'artista (un cartello, un formato) nel raggiungere e rivelare ciò che è segretamente, inaspettatamente, gloriosamente nascosto dentro di noi. Il progetto della Wearing concerne una sorta di sottile democrazia visuale, che inventa una piattaforma politica dalla quale parlare. Le parole possono contraddire, o negare, o valorizzare l'abbondanza di dettagli fornita dalle immagini: il contegno, l'espressione, il guardaroba o il linguaggio del corpo dello *speaker*. Sono come un'inversione dei grandi ritratti della famiglia reale eseguiti da Goya, nei quali la posizione e i vestiti di chi posa, insidiano e ironizzano l'immagine che i nobili soggetti dell'artista volevano comu-

political assassin, unseen in the darkness. The event here is the spectacularization of political history, the process of creating the official story. The central figures, the speakers, are God-like; the edges are more spectral. These are not posed pictures, but, almost unbelievably, completely candid, 'straight photography'. Griffiths' portraits are indeed, highly unofficial.

Scottish artist Wendy McMurdo takes our expectations of identity – that it must be singular and irrepeatable, above all – and inverts them by digitally manipulating her subject into twins, triplets, quintuplets of their former selves. The specificity of identity in the photographic portrait is morphed into a compendium of possible selves, of unlikely doubles standing in for the unique self. Like the pluralistic views of Cubist paintings, her *doppelgänger* pictures offer multiple and contradictory portraits which are deceptive, theatrical. These are not twins; this is the great fantasy of meeting oneself, of viewing the self not from the inside, but from some other, safer place.

A.H.: *You know, there's a lot of details in (*The Birds*); it's absolutely essential because these little nuances enrich the overall impact and strengthen the picture.*

In Gillian Wearing's series, *Signs that say what you want them to say and not signs that say what someone else wants you to say*, the artist offered hundreds of random passers-by the occasion to speak what's on their mind, writing the chosen words which they crave to say. Bland or insightful, these messages are more visual than literal, framed within the artist's very careful formal limitations (one board, one format) in accessing and revealing what is secretly, unexpectedly, gloriously inside us. Wearing's project is a subtle sort of visual democracy, inventing a kind of political platform from which to speak. The words can contradict, or deny, or enhance the wealth of details provided in the images: the demeanour, expression, wardrobe and body language of the speaker. They are like an inversion of Goya's grand portraits of the royal family, in which the sitters' stance and dress undermine and ironizes the image which the artist's noble subjects wanted to convey. Wearing presents her subjects with a kind of completeness and empathy which demonstrates her deep understanding of the human psyche. The photographs enrich the written message with the details of the portrait, of the potential conflict between the outer self and the release of one's thoughts.

Catherine Yass's photographs are in some cases like Flem-

nicare. La Wearing presenta i propri soggetti con una completezza e un'empatia che dimostrano la sua profonda comprensione della psiche umana. Le fotografie arricchiscono il messaggio scritto con i dettagli del ritratto, con il potenziale conflitto fra l'Io visibile e la liberazione del suo pensiero.

Le fotografie di Catherine Yass sono in alcuni casi simili alla ritrattistica fiamminga: niente cielo, niente terra, solo facce e busti visti di fronte a rivendicare la propria identità. I dettagli, comunque, si insinuano per dare forma all'immagine: un candelabro per suggerire opulenza, luci scintillanti per suggerire l'importanza di chi posa, come se fosse il soggetto di un quadro glorioso. La Yass, nelle sue fotografie, celebra la specie umana; le persone che sceglie di onorare sono sempre direttamente coinvolte nella realizzazione del lavoro, come i due direttori del museo che hanno ospitato le sue opere per la prima volta. La Yass associa un negativo e una diapositiva per formare un'immagine sola, creando una specie di doppia, eccessiva presenza. La fotografia che ne risulta sovrappone i colori naturali del positivo a quelli irreali e artificiali del negativo, formando con i suoi blu ultraterreni e i contrasti abbaglianti, la tavolozza yassiana. Come la McMurdo, anche Catherine Yass sperimenta il doppio, in una specie di intersezione degli elementi reali e irreali della fotografia.

A.H.: *Alla fine [ne* Gli Uccelli*], prima di salire in macchina, la ragazzina chiede: "Posso portare gli uccelli d'amore?" Allora significa che qualche cosa di buono sopravvive attraverso questa coppia di 'love birds'. [...] Sì, e questo prova che la parola amore è una parola piena di sospetto.*

Come riflessa nello specchio a tre facce di un camerino hollywoodiano, Bunny (da *Bunny Gets Snookered,* 1997, un lavoro sculureo dell'artista) è seduta e si gira in modo da presentare il proprio lato migliore, decapitato e capovolto. Un paio di calze da donna vuote, frettolosamente riempite con l'imbottitura di un cuscino, creano delle provocanti gambe divaricate, che sono anche ben fatte, ma esattamente che forma hanno? Nervose, divaricate in modo fatale e, soprattutto, morte, sottintendono una sessualità accessibile, eppure rimangono stancamente insensibili, venate di cicatrici. Bunny (come le ragazze di *Playboy*?) è una specie di attrazione necrofiliaca. Sembra averne abbastanza della sessualità, sembra essere annoiata dal desiderio così come dalla mutilazione e dalla violenza. Lucas usa la fotografia per estendere questo coraggioso e disturbante lavoro sculureo ad altre arene, permettendogli, nella sua incarna-

ish portraiture painting: no sky, no earth, just faces and torsos seen straight on, claiming who they are. Details, however, creep in to inform the picture: a chandelier, suggesting affluence; bright lights suggesting the sitter's merit as the subject of a glorious portrait. Yass celebrates humankind in her pictures; the humans she chooses to celebrate are always those directly involved in the work's realization, such as these two museum directors, where the work was first shown. Yass combines a positive transparency and a negative into one image, creating a kind of doubled, excessive presence. The resulting image overlaps the natural colours of the positive with the uncanny, artificial ones of the negative, resulting in this distinctly Yassian palette, with its unearthly blues and dazzling contrasts. Like McMurdo, she too experiments with a kind of double, in an intersection of photography's real and unreal sides.

A.H.: *At the end (of* The Birds*) the little girl asks, 'Can I take my lovebirds along?' ... It all goes to show that, with a little effort, even the word 'love' can be made to sound ominous.*

As if seen in the three-way mirror of a Hollywood dressing room, Bunny (from *Bunny Gets Snookered*, 1997, a sculptural work by the artist) sits, turning to display her best angle, decapitated and twisted. An empty pair of ladies' stockings, roughly stuffed with cushion padding, create provocative, open legs which are shapely, yes, but what shape exactly is that? Stringy, weirdly straddled, and above all dead, they are stand-ins for available sexuality, and yet are tiredly unresponsive, veined with scars. Bunny (like the *Playboy* magazine playmates?) is a sort of necrophiliac's centrefold. She seems sick with sexuality, as bored with desire as she is with violence and mutilation. Lucas uses photography to stretch this bold, disturbing sculptural work into other arenas, allowing it to address, in its photographic incarnation, ideas of the photograph as a fetish, the use of photography in enhancing sexual content – in turning a few tangled pairs of stockings into an icon of dangerous and extreme manipulations of the human body.

Love deteriorates into rage, into permanent psychological scars, into images of reckless emotion in Sam Taylor-Wood's photographs and video works. The human body as a sort of receptacle of sexual desire, frustration and expectation – in an unresolved battle – stands up in the face of uncontrollable emotion, resilient to its blows. The damage is being done as we watch, and no one is comfortable with admitting that if love and sex are not always fulfilling, they should at least be

zione fotografica, di indicare l'idea della fotografia come feticcio, l'uso dell'immagine per esaltare il contenuto sessuale – mutando qualche paio di collant arrotolati in un'icona di estrema e pericolosa manipolazione del corpo umano.

L'amore si deteriora in odio, in cicatrici psicologiche incurabili, in immagini di incauta emotività nel lavoro fotografico e nei video di Sam Taylor-Wood. Il corpo umano come ricettacolo di desiderio sessuale, di frustrazione e di aspettativa – in una lotta irrisolta – si erge di fronte all'emozione incontrollabile, elastico ai suoi colpi. Il danno è fatto nel momento in cui guardiamo e nessuno si sente a proprio agio nell'ammettere che se sesso e amore non sempre sono soddisfacenti almeno dovrebbero essere disponibili. Sbagliato, e il conflitto ribolle ancora una volta. Nei film di Hitchcock, come nei lavori di Sam Taylor-Wood, il compimento dell'amore o la riconciliazione reggono il racconto ma il tema centrale è essenzialmente tangenziale alla condizione degli amanti (*Gli Uccelli*, ma anche *Notorious*, *Vertigo*, *La finestra sul cortile*, fra gli altri). Il lavoro di Taylor-Wood è sicuramente il più cinematografico fra quelli qui presentati, prende a prestito dal film per condurci a volte verso un trauma insopportabile, a volte al piacere sessuale e a volte all'usuale confusione dei pensieri costanti. Nel suo lavoro, lo smalto è lucido e raffinato, le emozioni invece, in un contrasto affascinante, sono grezze, primordiali e selvagge.

A.H.: *La dimensione dell'immagine è molto importante per l'emozione, soprattutto quando l'immagine viene usata per creare l'identificazione con il pubblico.*

Il lavoro di Zarina Bhimji, *Pleasure Deferred,* ha le fattezze di una costellazione, una grande galassia di colori e forme cangianti che infine si rivela in tutta la sua imbarazzante normalità: quest'ultima è uno stupefacente e glorioso primo piano di una retina per capelli, ingrandita a proporzioni monumentali. Come in certe immagini del dopoguerra, da Oldenburg a Koons, le foto di Zarina Bhimji si appropriano del luogo comune e lo elevano al regno dello straordinario, semplicemente ingrandendola. È una metafora per spostamento, prendere il proprio precario ruolo sociale di *outsider* e collocarlo come il luogo privilegiato da cui osservare il proprio spazio all'interno della cornice dell'esistenza quotidiana. In *Pleasure Deferred*, l'artista posiziona il proprio sguardo come se fosse innaturalmente vicino al soggetto e comunica che il proprio punto di vista è completamente diverso – politicamente, soggettivamente, figurativamente – da quello di qualsiasi altro spettatore.

available. In Hitchcock films, as in Taylor-Wood's work, love's fulfilment or reconciliation always drives the narrative, but the central theme in each film is essentially tangential to the lovers' predicament (*The Birds*, but also *Rear Window, Notorious, Vertigo*, among others). Taylor-Wood's work is certainly the most cinematographic of the artists presented here, borrowing film to ease us into sometimes unbearable trauma, sometimes sexual delight, sometimes the usual confusion of constant thoughts. The veneer is polished and resolved, while the emotions behind her work, in fascinating contrast, are raw, hoary and untamed.

A.H.: *The size of the image is very important to the emotion, particularly when you're using that image to have the audience identify with it.*

Zarina Bhimji's work, *Pleasure Deferred*, seems to be a kind of constellation, a grand galaxy of moveable form and colour which is finally revealed in all of its perplexing ordinariness: this is a greatly magnified, glorious close-up view of a hairnet, enlarged to monumental proportions. Like a certain strain of postwar imagery, from Oldenburg to Koons, Bhimji's picture takes the commonplace and, simply by overscaling it, propels it into the realm of the extraordinary. It is kind of metaphor for displacement, of taking one's own unguaranteed position on society as an outsider, and locates it as the privileged vantage point from which to observe the framework of daily existence. In *Pleasure Deferred*, the artist positions her gaze as unnaturally close to her subject and signals her viewpoint as different – politically, personally, figuratively – from that of any other spectator.

Paul Graham was among the first to use colour in serious art photography, back in the 1980s, and with this new series, his colours have become more lush and jewel-like than ever before. The giant expanse of sky, with a airplane wing and motor hanging as if suspended and motionless, was taken from the very limited partial view afforded by a airplane window. In this work, Graham took a trip round the world, photographing it with timed regularity, marking time and space by shooting an image of the direction in which he was heading. The scale of his project outsizes even the huge proportions of these photographic prints: it is indeed global in its scope. Like the picture of the Earth taken by the astronauts from the moon, this is yet another attempt in photography finally to take in everything, be everywhere: to have the camera cover all my steps and lead me where to go next.

A.H.: *I was worried about the audience sitting through parts*

Paul Graham è stato uno dei primi, negli anni Ottanta, a usare il colore nella fotografia "artistica", e con queste nuove serie i suoi toni sono diventati più lussureggianti e preziosi che mai. La gigantesca estensione del cielo, con un'ala d'aeroplano e il motore come sospeso e immobile, è stata ripresa dalla vista molto parziale e limitata offerta da un finestrino. Per questo lavoro Graham ha fatto un giro intorno al mondo, fotografandolo con cronometrata regolarità, segnando il tempo e lo spazio con lo scatto di un'immagine del luogo in cui si stava dirigendo. La scala di questo progetto sorpassa di misura persino le grandi dimensioni di queste stampe fotografiche: è realmente globale nel suo scopo. Così come nelle immagini della Terra riprese dalle astronavi sulla luna, in queste vi è il tentativo della fotografia di racchiudere tutto, di essere ovunque: che l'apparecchio fotografico segua ogni mio passo e mi conduca dove devo andare.

A.H.: *Ho temuto che la fama che il film [*Gli Uccelli*] si era creato facesse perdere la pazienza al pubblico: "Sì, sì, va bene, ma fateci vedere gli uccelli, dove sono gli uccelli".*

L'aspettativa sembra preoccupare i divani di Sarah Jones, ripresi durante un *training* ospedaliero per studenti di psicoanalisi. Quest'artista taglia con molta attenzione le sue fotografie e inscrive sezioni auree e altre geometrie classiche nel loro formato perfettamente quadrato, esaltandone la similitudine con la pittura antica. La grande espansione della parete dietro al divano è uno splendido esempio di monocromo, che dona all'immagine un'aria di perpetua attesa: per l'arrivo del paziente, per fare un viaggio nella psiche, e per gli "aspiranti Freud" che cercano la loro strada nei labirinti della psicoanalisi. I divani sono immobili, eppure tiepidi, e conservano ancora l'impronta degli innumerevoli soggetti che vi si sono sdraiati sopra: non è tanto l'immagine di un divano, quanto quella di un corpo assente.

A.H.: *[...] sentivo che [ne* Gli Uccelli*], dopo l'attacco dei gabbiani ai bambini durante il picnic [...] il pubblico doveva riposarsi un attimo, prima di risprofondarsi nell'orrore. [...] Non si tratta di una gabbia dorata, ma di una gabbia di sciagura.*

L'effetto della guerra su una nazione e il suo popolo è un genere tradizionalmente importante nella creazione storica delle immagini. Nel lavoro di Willie Doherty, la guerra in Irlanda lascia un segno profondo e indelebile, che penetra nel linguaggio, nei dettagli visivi della paura quotidiana e lascia amarezza, frustrazione e rabbia. Le sue immagini sono marchiate dalla resistenza al conflitto, in modo tale da

of the picture and thinking to itself, 'Come on. Where are the
Birds? Let's get on with it.'

Expectation seems to occupy Sarah Jones' painterly couches, photographed at a training hospital for student psychoanalysts. Jones takes great care to crop her photographs and inscribes golden sections and other classic geometries into their perfectly square format, enhancing their similarity to Old Master painting. The great expanse of wall behind the couch is a marvelous kind of monochrome, lending the picture an air of perpetual waiting: for the patient to arrive, to take a journey into the psyche, and for the 'budding Freuds in training' to find their way through the labyrinth of psychoanalysis. The couches are still, yet warm with the imprint of countless subjects who have lain upon it: it is an image not so much of a couch, but of an absent body.

A.H.: *I felt that after the attack of the birds on the children at*
the birthday party … we should give the audience a rest
before going back to the horror … This isn't a gilded cage, but
a cage of misery.

The effects of war on a country and its people has been traditionally a *grand genre* in historical picture-making. In Willie Doherty's work, the war in Ireland leaves a deep, indelible aftermath, penetrating into language, into the visual details of everyday fear, and bitterness, and frustration, and anger. His images are marked by a resistance in the face of conflict, to position the self in relation to the constant presence of the Other. The field of vision seems dramatically narrowed down, claustrophobic, in finding a solution to the genre of documentary photography which can penetrate into an artistic practice. In Doherty's photographs and sound and video installations, the gaze is ambiguous: are we witnessing through the eyes of the victim, or of the perpetrator? And why do these positions so skew my view of the same reality?

Richard Billingham's portraits of his immediate family, taken in their council flat home, were originally meant as sources for painted pictures while Billingham was still in art school. The family – alcoholic father Ray, chainsmoking, thunderous mum Liz, and brother Jason – is in economic, emotional, physical disarray, perpetually on the verge of exploding into chaos. French social theorist Pierre Bourdieu considered photography essentially a family affair, identifying its most symbolic benchmarks and lending it cohesion. With Billingham, photography intrudes upon scenes of family life which, more usually, are left mercifully unre-

dare un ruolo all'individuo in relazione a una realtà spaventosa e alla costante presenza dell'Altro. Il campo visivo sembra drammaticamente limitato, claustrofobico, alla ricerca di un compromesso: una fotografia documentaristica può così penetrare nella pratica artistica. Nelle fotografie e nelle installazioni video e sonore di Doherty lo sguardo è ambiguo: siamo testimoni attraverso gli occhi della vittima o del carnefice? E come mai questi punti di vista stravolgono così profondamente il mio sguardo sulla medesima realtà?

I ritratti dei familiari di Richard Billingham, fatti nel suo appartamento all'interno di una casa popolare, originariamente dovevano essere spunto per dei quadri che l'artista voleva realizzare quando ancora studiava in Accademia. La famiglia – Ray, il padre alcolizzato, Liz, la fragorosa mamma tabagista, e il fratello Jason – è in mezzo al disordine economico, emozionale e fisico, costantemente al limite del caos. Pierre Bourdieu considerava la fotografia essenzialmente una questione famigliare, atta a fisssarne i momenti e ad accrescerne la coesione. In questo caso la fotografia ci introduce in scene domestiche che, normalmente, vengono pietosamente dimenticate. "La mia intenzione non è di scioccare, offendere, stupire o essere politico", ha detto Billingham. "Solamente di fare un lavoro il più possibile significativo a livello spirituale". Il suo essere all'interno della situazione lo allontana dal rischio del voyeurismo. Immagini come queste, così piene di informazioni, di temi e di emozioni, sembrano resistere alla marea dell'imminente collasso familiare.

François Truffaut: *Questo equivale a risolvere dei problemi di tempo giocando con lo spazio.*
A.H.: *Sì, ne abbiamo già parlato, la regia nel cinema esiste sia per contrarre il tempo, sia per dilatarlo a seconda dei nostri bisogni, a volontà.*

Per alcuni fotografi, l'immagine è ovunque la si voglia cercare; per Steven Pippin la stessa macchina fotografica può essere nascosta in qualsiasi luogo. Trasformare qualsiasi tipo di contenitore, da una cabina per gli autoscatti a un caravan o una lavatrice in un gigantesco stenoscopio non è mera sperimentazione di "fotografo dilettante", come lui stesso ama definirsi. Il lavoro di Pippin, fra quelli qui presentati, è probabilmente il più scultoreo, tuttavia la bellezza dell'immagine creata non deve essere messa in ombra dai mezzi elaborati con i quali è stata costruita. L'immagine lentamente costruita, quasi come un dagherrotipo che registra i lunghi tempi di esposizione neces-

corded. 'It is not my intention to shock, to offend, sensationalize, be political or whatever', Billingham has said. 'Only to make work that is as spiritually meaningful as I can make it'. His proximity to the situation saves it from turning voyeuristic, in images so packed with information, patterns and emotion they seem to be holding up against the tide of the family's imminent collapse.

François Truffaut: *You solve the problem of time by manipulating space.*
A.H.: *That's right. Film can be used to contract time or extend it at will, in accordance with our needs.*

For some photographers, the picture is anywhere we choose to look for it; for Steven Pippin, the camera itself is hidden everywhere. Transforming any sort of container, from a photobooth to a caravan or a washing machine, into a giant pinhole camera is not merely about the experimentation of an 'amateur photographer', as he likes to call himself. Pippin's project, among those presented here, is probably the most sculptural, but the beauty of the resulting image is not to be overshadowed by the elaborate means with which it was constructed. The slowly built, daguerreotype-like image, recording the long exposure time needed for these makeshift cameras, creates images which are delicate, oddly still, as if extracted painfully from this monstrous machine forced to perform its new, unnatural task. The photograph, above all, records the strain of its production.

John Stezaker does not use a camera in his witty, uncanny photo-collages. Drawing from a collection of thousands of found images, cut from film stills, magazines, catalogues, encyclopaedias, postcards and other readily available sources of printed pictures, his work elevates the bland imagery of kitsch into truly uncanny, visual hybrids. They are jarring certainly, and they feign a kind of naturalness with which they are produced; the more you look at them, the more miraculous they actually seem. Stezaker has described his project as if extracting hidden messages from the proliferation of images, as if discovering an 'embedded mythological system or world' lying just beneath the surface of visual culture. His earlier work had a kind of handmade scissors-and-glue feeling which lent them an air of childishness, of play (Stezaker says her works on the floor, with images spread out all around him, like 'a playpen') while his later work has adopted a kind of seamlessness which, in fusing age and gender (say, a small boy with a grown woman), preys upon the human body's very symmetry. The world, for

sari a queste macchine fotografiche improvvisate, è delicata, stranamente immobile, come se fosse stata estratta in modo indolore da questi mostruosi apparecchi forzati a compiere il loro nuovo, innaturale compito.

John Stezaker non usa la macchina fotografica per i suoi pungenti e inquietanti collage. I suoi sono disegni da una collezione di migliaia di immagini trovate fra i fotogrammi di un film, nelle riviste, nei cataloghi, nelle enciclopedie, fra le cartoline e altre immagini stampate già pronte. Il suo lavoro eleva il semplice immaginario *kitsch* all'ibrido visivo realmente sconosciuto. Sono certamente sorprendenti e fingono una specie di naturalezza attraverso la quale acquistano vita; più le si guarda, più sembrano miracolose. Stezaker ha descritto il suo progetto come l'estrapolazione di messaggi nascosti nella proliferazione delle immagini, come se si scoprisse un "sistema mitologico o un mondo sommersi", proprio al di sotto della superficie della cultura visiva. I suoi primi lavori davano la sensazione di un lavoro di collage artigianale che richiamava i giochi dell'infanzia (Stezaker lavora sul pavimento, con le immagini sparse ovunque, come se fosse in un "recinto per bambini"), mentre i lavori più recenti hanno adottato un'incoerenza, nella fusione di età e di generi (ad esempio una donna con un bambino), che nega la reale simmetria del corpo umano. Secondo Stezaker il mondo è un caleidoscopio in cui i frammenti visivi si uniscono, costruiscono il proprio dialogo particolare e quindi scivolano via nuovamente separati.

I film di Hitchcock erano pittorici (come i lavori di Richard Billingham e di Sarah Jones); erano sessualmente ambigui, carichi e minacciosi (Sarah Lucas, John Stezaker e Sam Taylor-Wood); avevano un immaginario sottile e studiato, che si tratteneva più del necessario sui dettagli (Zarina Bhimji, Stuart Smith); erano pieni di colpi di scena e di sorprese (Thomas Demand, Wendy McMurdo, David Griffiths). I film di Hitchcock erano anche tecnicamente coraggiosi (come Steven Pippin e Catherine Yass) e sempre, sempre innestati in un'esistenza quotidiana comunque capace di divenire fastidiosamente poco conosciuta (Willie Doherty, Paul Graham e Gillian Wearing). *Gli Uccelli* finisce con uno strano, vibrante silenzio, mentre gli uccelli si zittiscono vittoriosi e un nuovo e più strano giorno riempie l'immagine.

[1] Le frasi citate sono state tratte da: François Truffaut, *Il cinema secondo Hitchcock,* Nuova Pratiche Editrice, Parma, 1977, pp. 235-248.

Stezaker, is an kaleidoscopic tumbler in which visual fragments come together, enter into their own peculiar dialogue, and then drift off, separately, again.

Hitchcock's 'pictures' were painterly (like the work of Richard Billingham and Sarah Jones); they were sexually ambiguous, loaded and threatening (like Sarah Lucas, John Stezaker and Sam Taylor-Wood); they had subtle, studied imagery, dwelling longer than necessary on detail (Zarina Bhimji, Stuart Smith); they are full of twists and surprises (Thomas Demand, Wendy McMurdo, David Griffiths). Hitchcock's films were also technically daring (like Steven Pippin and Catherine Yass) and always, always rooted in everyday life yet capable of growing disturbingly unfamiliar (Willie Doherty, Paul Graham, and Gillian Wearing). *The Birds* ends with an odd, quaking silence, as the birds quiet down in victory, and a new, stranger day, fills the Picture.

[1] All quotes from Alfred Hitchcock, interviewed by François Truffaut, *Hitchcock by Truffaut, the Definitive Study,* François Truffaut, Paladin/ Harper Collins, London, 1978, p, 440-461.

Richard Billingham

NRAL 31, 1994

Fotografia a colori su alluminio
Colour photograph on aluminum
80x120 cm
Photo Studio 3

Zarina Bhimji

Pleasure Deferred, 1997

Cibachrome su supporto luminoso
Cibachrome transparency
on light box
88x105.5x5 cm

Thomas Demand

Parkhaus, 1996

Fotografia a colori
Colour photograph, ed. 2/5
135x165 cm

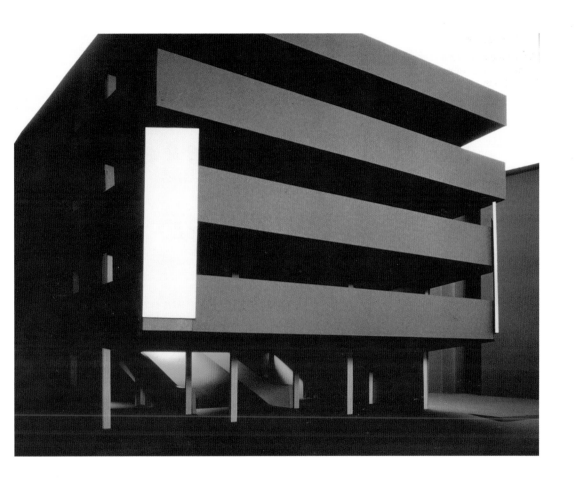

Willie Doherty

Discarded Number Plate, 1996

Cibachrome su alluminio
Cibachrome on aluminum, ed. 1/3
76x101.5 cm
Photo Gorni

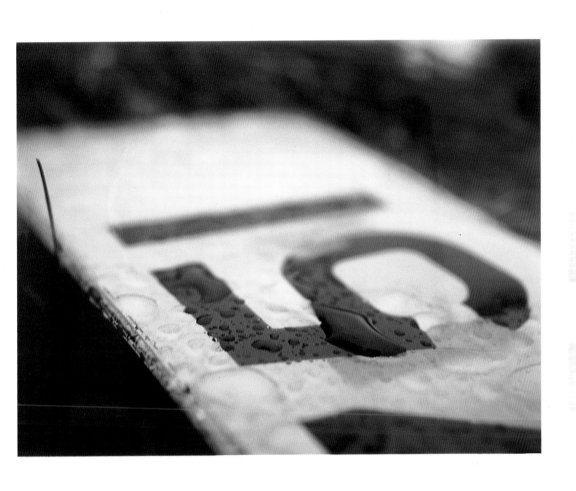

Paul Graham

Untitled (+19:18 hrs), 1997

Fotografia a colori "Fujicolour
longlife" / Colour photograph
Fujicolour longlife
120x160 cm

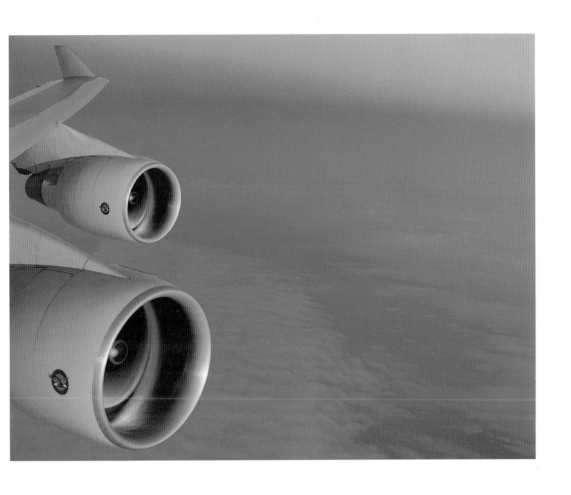

David Griffiths

I Spy Stranger n. 9, 1995

Parte di un trittico/Part of a
triptych
Fotografia in bianco e nero
Black and white photograph
50.8x61 cm

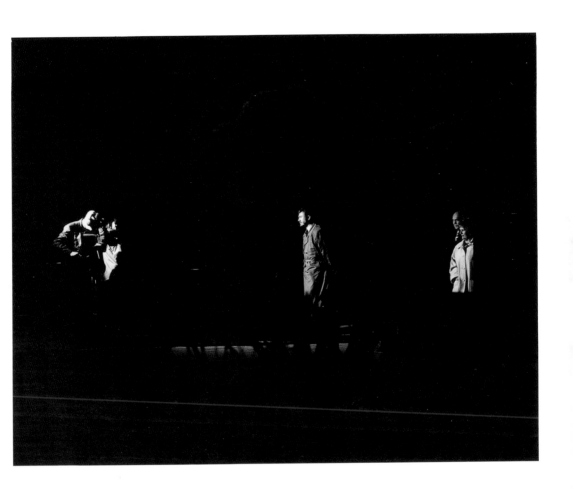

Sarah Jones

Consulting Room # 9 (Couch),
1997

C-type su alluminio
C-type on aluminum
152.4x152.4 cm

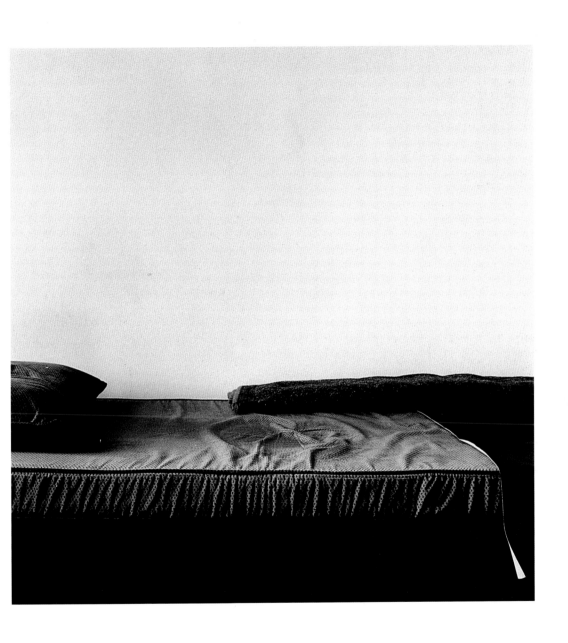

Sarah Lucas

Black and White Bunny N. 1,
1997

Fotografia su MDF
Photograph on MDF
122x91.5 cm

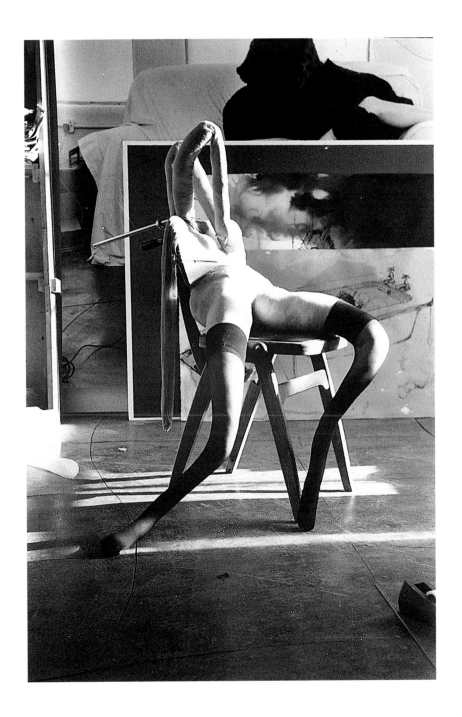

Wendy McMurdo

Helen, Sheffield, 1996

Composizione digitale, stampa a
colori negativa / Digital
composition, negative colour print
120x120 cm

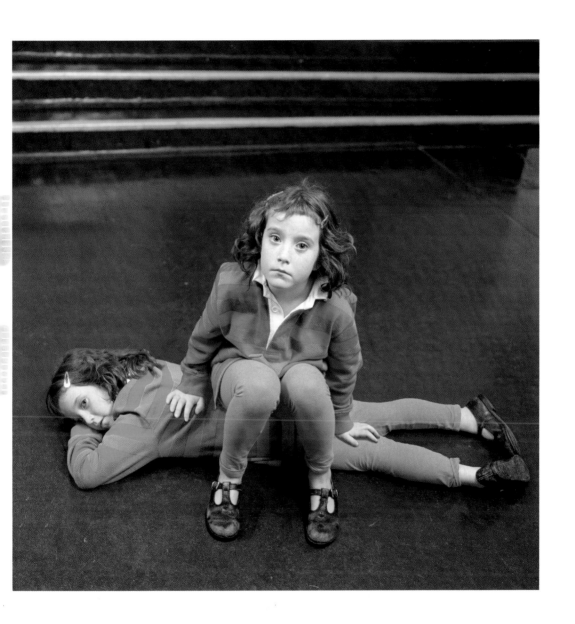

Steven Pippin

Mall-Adjustment (Photo Booth Self-Portrait), 1996

Fotografia in bianco e nero
Black and white photograph
154x92.4 cm

Stuart Smith

Untitled, 1997

Fotografia in bianco e nero
Black and white photograph
20x20 cm

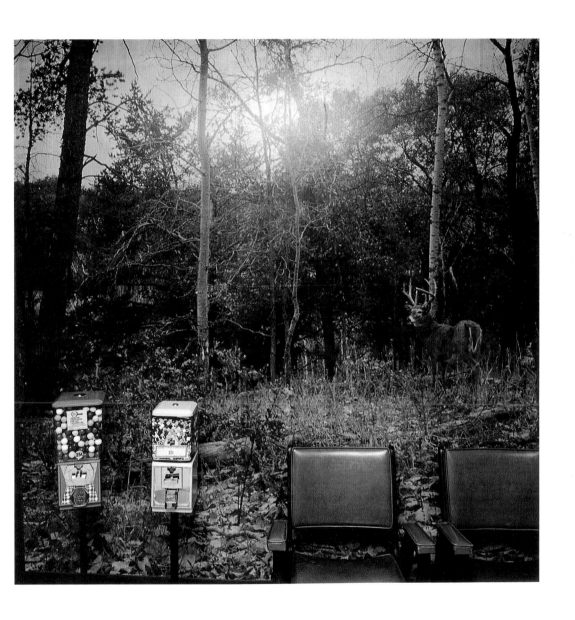

John Stezaker

Third Person, 1990

Collage
62x44 cm

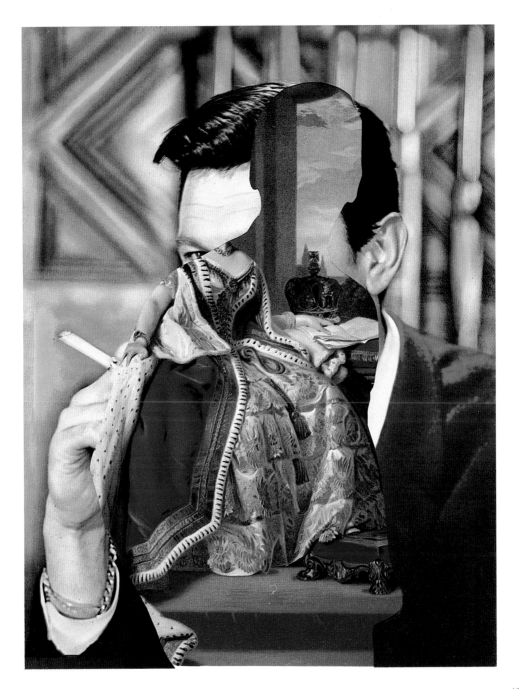

Sam Taylor-Wood

*Five Revolutionary Seconds
VII*, 1997

Foto a colori / Colour photograph,
ed. 1/3

Gillian Wearing

Signs that say what you want them to say and not signs that say what someone else wants you to say
La mafia è male, Vide 'o mare, W punkabestia, Siete carine, Mi ritrovo nel caos, Napoli risorgerà, 1994

6 cibachrome su alluminio
6 cibachromes on aluminum
40x30 cm ciascuna/each
Photo Studio 3

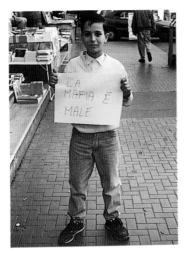

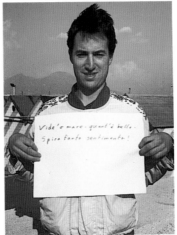

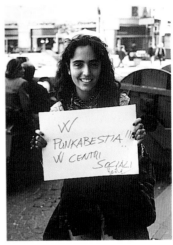

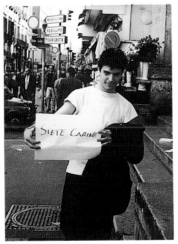

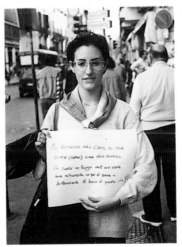

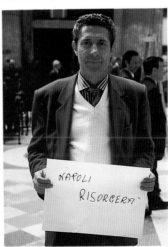

Catherine Yass

Portrait, Bowes Museum, 1996

Dittico / Diptych
Fotografia a colori su supporto
luminoso / Colour photograph on
light box
70x55 cm ciascuna/each

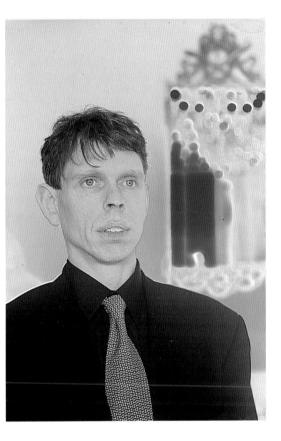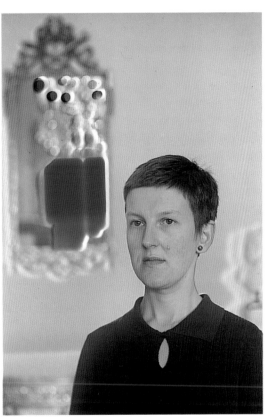

Biografie
Biographies

Richard Billingham

Birmingham, 1970
Vive e lavora a Londra
He lives and works in London

Mostre Personali
Solo Exhibitions
1996
Anthony Reynolds Gallery,
London
National Museum of Film and
Photography, Bradford
Portfolio Gallery, Edinburgh
1997
Luhring Augustine, New York
Regen Projects, Los Angeles
Galerie Jennifer Flay, Paris
Galleria Massimo De Carlo,
Milano

Mostre Collettive
Group Exhibitions
1994
Who's Looking at the Family?,
Barbican Art Gallery, London
1995
Night and Day, Anthony Reynolds
Gallery, London
1996
Passage à l'Acte, Galerie Jennifer
Flay, Paris
Herkunft?, Fotomuseum,
Winterthur, Deutschland
Radical Images, 2nd Austrian
Triennial on Photography, Graz,
Österreich
Radical Images, Museum of
Contemporary Art, Szombathely,
Magyarország
Galerie du Jour Agnés B., Paris
Life/Live, ARC, Musée d'Art
Moderne de la Ville de Paris,
Paris (Mostra itinerante/
Travelling exhibition)
New Photography 12, Museum of
Modern Art, New York
Photos Leurresn Mois de la Photo,
Galerie de Jour Agnés B., Paris
Blick von Innen, Galerie Monika
Reitz, Frankfurt

Full House, Kunstmuseum,
Wolfsburg, Deutschland
SIAFO, Seoul, South Korea
1997
Anthony Reynolds Gallery, London
*The Citybank Private Bank
Photography Prize*, Royal College
of Art, London
Vis-à-vi(e)s, Galerie Art et Essai,
Université Rennes 2, Rennes
Museum of Contemporary Art,
Sydney
Observaties/Observations, PTT
Museum, Den Haag
Families/Friends/Strangers,
Centro Gallego de Arte
Contemporanea, Santiago de
Compostela, España
Angels, Angels, Kunsthalle, Wien
Home Sweet Home,
Deichtorhallen, Hamburg
Strange Days, Claudia Gian
Ferrari Arte Contemporanea,
Milano

Zarina Bhimji

Mbarara (Uganda), 1963
Vive e lavora a Londra
She lives and works in London

Mostre Personali
Solo Exhibitions
1992
I will always be here, Ikon
Gallery, Birmingham
1995
Kettle's Yard, University of
Cambridge, Cambridge

Mostre Collettive
Group Exhibitions

1989
Towards a Bigger Picture,
Victoria and Albert Museum,
London (Mostra itinerante/
Travelling exhibition)
1990
Selections 5, Biennial Exhibition

from Polaroid Collection,
Photokina '90, Köln (Mostra
itinerante/Travelling exhibition)
Intimate Distance, The
Photographer's Gallery, London
(Mostra itinerante/Travelling
exhibition)
*Fabled Territories (New Asian
Photography in Britain)*, Leeds
City Galleries, Viewpoint (Mostra
itinerante/Travelling exhibition)
*Shocks to the System '90s Political
Art*, Arts Council Collection
1993
Antwerp '93, MUHKA Museum,
Antwerp
1994
INIVA, Opening exhibition,
London
1995
The Impossible Science of Being,
The Photographer's Gallery,
London
1996
In/Sight, Guggenheim Museum,
New York
1997
No Place (like home), Walker Arts
Centre, Minneapolis
Public Relations, Stadthaus, Ulm,
Deutschland
Necessities (Working Title), 2nd
Johannesburg Biennial,
Johannesburg
Photo 98, Anno Britannico della
Fotografia e dell'Immagine
Elettronica/British Year of the
Photografy and the Electronic
Image, Leeds (Mostra itinerante/
Travelling exhibition)
*British Contemporary
Photography*, NGBK Photography
Group, Berlin (Mostra itinerante/
Travelling exhibition)
Inserts, In collaborazione con/In
collaboration with QJM Magaine
and Lab Ruskin School of
Drawing & Fine Art, Oxford
Out of India, Queens Museum of
Art, New York
Strange Days, Claudia Gian

Ferrari Arte Contemporanea,
Milano

Thomas Demand

München (Deutschland), 1964
Vive e lavora a Berlino e Londra
He lives and works in Berlin and
London

Mostre Personali
Solo Exhibitions
1991
Galerie Guy Ledune, Bruxelles
1992
Galerie Tanit, München
Forderkoje Art Cologne, Köln
1994
Galerie Tanit, Köln
Galerie Blancpain-Stepcynski,
Genève
1995
Victoria Miro Gallery, London
Galerie Guy Ledune, Bruxelles
1996
Galerie de l'Ancienne Poste, Le
Channel, Calais
Galerie Tanit, München
Max Protetch, New York
1997
Centre d'Art Contemporain de
Vassivière en Limousin, France
Victoria Miro Gallery, London

Mostre Collettive
Group Exhibitions
1990
Gezweigt in sieben Mosigwellen,
Galerie Löhrl, Mönchengladbach,
Deutschland
1991
Quellen und Ergänzungen,
Galerie der Künstler, München
1993
*Het Intelectuele Geweeten van de
Kunst*, Galerie d'Eendt, Amsterdam
1994
Scharf in Schauen, Haus der
Kunst, München

1995
*Ulrich Meister und Thomas
Demand*, Galerie Christian
Gögger, München
*Herbert Hamak, Thomas Demand
et Stephen Dean*, Galerie Renos
Xippas, Paris
*Ars Viva 1995, Thomas Demand,
Wolfgang Tillmanns, Barbara
Probst und Jochen Lempert*,
Kunstverein, Frankfurt;
Kunsthalle, Nürnberg, Deutschland
Temples, Victoria Miro Gallery,
London
Frühe Werke, Galerie Tanit, Köln
1996
*Fotografia nell'Arte Tedesca
Contemporanea*, Claudia Gian
Ferrari Arte Contemporanea,
Milano
Ritratti di Interno, Studio La
Città, Verona
Prospect '96, Kunstverein,
Frankfurt
Raumbilder-Bildräume, Museum
Folkwang, Essen
Campo 6: The Spiral Village,
Galleria Civica d'Arte
Contemporanea, Torino (Mostra
itinerante / Travelling exhibition)
New Photography 12, Museum of
Modern Art, New York
1997
Broken Home, Green Naftali, New
York
Defamiliar, Regen Projects, Los
Angeles
Strange Days, Claudia Gian Ferrari
Arte Contemporanea, Milano

Paul Graham

Stafford (U.K.) 1956
Vive e lavora a Londra
He lives and works in London

Mostre Personali
Solo Exhibitions
1979
Arnolfini, Bristol

1980
Ikon Gallery, Birmingham
1983
A1 - The Great North Road, The
Photographer's Gallery, London
1986
Beyond Caring, The
Photographer's Gallery, London
1990
Anthony Reynolds Gallery, London
1991
PPOW Gallery, New York
1993
New Europe, Fotomuseum
Winterthur, Schweitz (Mostra
itinerante / Travelling exhibition)
Bob van Orsouw, Zürich
1994
Television Portraits, Claire
Burrus, Paris
Anthony Reynolds Gallery,
London
1995
Le Case d'Arte, Milano
Empty Heaven, Kunstmuseum,
Wolfsburg, Deutschland
1996
Tate Gallery, London
Anthony Reynolds Gallery,
London

Mostre Collettive
Group Exhibitions

1984
Britain in 1984, The
Photographer's Gallery, London
(Mostra itinerante/Travelling
exhibition)
1987
Attitudes to Ireland, Orchard
Gallery, Derry
Recent Histories, Hayward
Gallery, London
1988
*The Art of Photography 1839-
1989*, Museum of Fine Arts,
Houston (Mostra itinerante/
Travelling exhibition)
*Through the Looking Glass,
Indipendent Photography in*

Britain 1946-1989, Barbican Art Gallery, London (Mostra itinerante/Travelling exhibition)
1991
British Photography from the Tatcher Years, Museum of Modern Art, New York
1992
Whitechapel Open, Whitechapel Gallery, London
More than One Photography, Museum of Modern Art, New York
1993
On the Edge of Chaos, Lousiana Museum, Humlebaek, Denmarck
1994
Seeing the Unseen, Thirty Sheperdess Walk, London
1996
Prospect '96, Kunstverein, Frankfurt
1997
Strange Days, Claudia Gian Ferrari Arte Contemporanea, Milano

Willie Doherty

Derry (Northern Ireland), 1959
Vive e lavora a Derry
He lives and works in Derry

Mostre Personali
Solo Exhibitions
1980
Installation, Orchard Gallery, Derry
1982
Siren, A.R.E., Belfast
1988
Two Photoworks, The Third Eye Centre, Glasgow, Scotland
Colour Works, Oliver Dowling Gallery, Dublin
1990
Unknown Depths, Fotogallery, Cardiff (Mostra itinerante/Travelling exhibition)
Same Difference, Matt's Gallery, London

1991
Tom Cugliani Gallery, New York
Unknown Depths, ICA, London
1992
Tom Cugliani Gallery, New York
Oliver Dowling Gallery, Dublin
Peter Kilchmann Gallery, Zürich
1993
Galerie Jennifer Flay, Paris
They are all the same, Centre for Contemporary Art, Ujazdowski Castle, Warszawa
30 January 1972, Douglas Hyde Gallery, Dublin
The Only Good One is a Dead One, Matt's Gallery, London (Mostra itinerante / Travelling exhibition)
1994
At the End of the Day, The British School at Rome, Roma
Kerlin Gallery, Dublin
1995
Galerie Jennifer Flay, Paris
Peter Kilchmann Gallery, Zürich
1996
Tell Me What You Want, Galleria Emi Fontana, Milano
In the Dark Projected Works by Willie Doherty, Kunsthalle, Bern
1997
Kerlin Gallery, Dublin
1997-98
Same Old Story, Matt's Gallery, London (Mostra itinerante/Travelling exhibition)

Mostre Collettive
Group Exhibitions
1981
Irish Exhibition of Living Art, Dublin
1983
New Artists, New Works, Project Centre, Dublin
1987
A Line of Country, Cornerhouse, Manchester
Directions Out, The Douglas Hyde Gallery, Dublin

1988
Ireland/Germany Exchange, Ulster Museum, Belfast
Matter of Facts, Musée des Beaux-Arts, Nantes
1989
Through the Looking Glass, Barbican Art Gallery, London
Three Artists, London Street, Derry
1990
The British Art Show, McLellan Galleries, Glasgow (Mostra itinerante/Travelling exhibition)
1991
Shocks to the System, Royal Festival Hall, London
Storie, Galleria Il Campo, Roma
Storie, Studio Casoli, Milano
A Place for Art?, The Showroom, London
1992
Time Bandits, Galleria Fac-Simile, Milano
Spielholle, Bockenheimer/University Underground Station, Frankfurt
1993
Prospect '93, Kunstverein, Frankfurt
An Irish Presence, Biennale di Venezia, Venezia
Critical Landscapes, Tokyo Metropolitan Museum of Photography
1994
Turner Prize, Tate Gallery, London
From Beyond the Pale, Irish Museum of Modern Art, Dublin
Cocido y Crudo, Museo Nacional Centro de Arte Reina Santa Sofia, Madrid
1995
It's Not a Picture, Galleria Emi Fontana, Milano (Mostra itinerante/Travelling exhibition)
Willie Doherty, Andreas Gursky, Moderna Museet, Stockholm
1996
Devant l'Histoire, Centre Georges Pompidou, Paris

Now Here, Lousiana Museum of Modern Art, Humlebaek, Danmark
Face à l'Histoire 1930 / 1996, Centre Georges Pompidou, Paris
1997
No Place (Like Home), Walker Art Center, Minneapolis, USA
Works That Reference The Landscape, Alexander and Bonin, New York
Città Natura, Palazzo delle Esposizioni, Roma
Identité, Le Nouveau Musée, Villeurbanne
Strange Days, Claudia Gian Ferrari Arte Contemporanea, Milano

David Griffiths

Cardiff (U.K.), 1961
Vive e lavora a Londra
He lives and works in London

Mostre Personali
Solo Exhibitions
1989
Proportionate Play, The Third Eye Centre, Glasgow, U.K.
1990
U7 Contemporary Art, London
1991
A Dialogue of Disclosure, Battersea Arts Centre, London
Free Fall, Camerawork, London
Luminary, The Photographer's Gallery, London
1993
Placemaking, The Central Space Gallery, London
1994
Boundaries of Reason, Gilmour Gallery, London
1995
I Spy Stranger, MK Expositieruimte, Witte de Withe, Rotterdam
Land, 152c Brick Lane, London
Nocturne, Oh! Rue des Éperonniers, Bruxelles

1997
I Spy Stranger, Lotta Hammer, London

Mostre Collettive
Group Exhibitions
1988
The Invisible Man, Goldsmith's Gallery, London
1989
March / April Programme, London Film Makers Co-op, London
1990
Riverside Open, Riverside Studios, London
1991
Post Morality, Kettle's Yard and Cambridge Darkroom, Cambridge
Art London '91, The Times Young Artist for London, London
1992
15 / 1, Malania Basarab Gallery, London
1993
Itself, Transmission Gallery, Glasgow
1994
Cologne Art Fair, Schipper et Kromer Galleries, Köln
The Institute of Cultural Anxiety, Works from the Collection, ICA, London
Touch, Gilmour Gallery, London
1995
Reserve-Lager-Storage, Oh! Rue des Éperonniers, Bruxelles
1996
50x50x50x50, Bank, London
Inner London, Delfina, London
1997
Galerie Rodolphe Janssen, Bruxelles
Strange Days, Claudia Gian Ferrari Arte Contemporanea, Milano

Sarah Jones

London, 1959
Vive e lavora a Londra
She lives and works in London

Mostre Personali
Solo Exhibitions

1987
F. Stop Gallery, Bath
1988
Watershed Arts Centre, Bristol
1993
Hales Gallery, London
1995
Consulting Room, Galerie du Dourven, France
Consulting Room (Couch), Camera Work Gallery, London
1997
Interim Art, London

Mostre Collettive
Group Exhibitions
1988
The Photographer's Gallery, London
1994
Photo 2, 152c Brick Lane, London
Dad, Gasworks Gallery, London
1995
Sick, 152c Brick Lane, London
Nobby Stiles, Vandy Street, Londra
1996-97
A.C.E.!, Arts Council Collection, Hatton Gallery, Newcastle (Mostra itinerante/Travelling exhibition)
New Contemporaries, Tate Gallery, Liverpool; Camden Arts Centre, London
Strange Days, Claudia Gian Ferrari Arte Contemporanea, Milano

Sarah Lucas

London, 1962
Vive e lavora a Londra
She lives and works in London

Mostre Personali
Solo Exhibitions
1992
Penis Nailed to a Board, City Racing, London

1993
The Shop (with Tracey Emin), 103 Bethnal Green Road, London
From Army to Armani (with Tracey Emin), Galerie Analix, Genève
1994
Got a Salmon On (Prawn), Anthony d'Offay Gallery, London
Where's My Moss, White Cube, London
1995
Supersensible, Barbara Gladstone Gallery, New York
1996
Sarah Lucas, Museum Boymans-van Beuningen, Rotterdam
Sarah Lucas, Portikus, Frankfurt
1997
The Law, St.Johns Lofts, London
Bunny Gets Snookered, Sadie Coles HQ, London
Car Park, Ludwig Museum, Köln

Mostre Collettive
Group Exhibitions
1988
Freeze, PLA Building, London
1992
Gladstone and Barbara Gladstone Gallery, New York
1993
Sarah Lucas and Steven Pippin, Project Room, Museum of Modern Art, New York
Young British Artists II, Saatchi Collection, London
1995
Minky Manky, South London Gallery, London
Brilliant! New Art from London, Walker Art Centre, Minneapolis, USA; Museum of Fine Arts, Houston
1996
Live / Life, ARC Musée d'Art Moderne de la Ville de Paris, Paris (Mostra itinerante/ Travelling exhibition)
1997
Sensation: Young British Artists

in the Saatchi Collection, Royal Academy of Art, London
Strange Days, Claudia Gian Ferrari Arte Contemporanea, Milano

Wendy McMurdo

Edinburgh, 1962
Vive e lavora a Edimburgo
She lives and works in Edinburgh

Mostre Personali
Solo Exhibitions
1995
Portfolio Gallery, Edinburgh
Site Gallery, Sheffield, U.K.
1995-96
In a Shaded Place, The Digital and the Uncanny (Mostra itinerante/Travelling exhibition)
1996
Montage Gallery, Derby, U.K.
F. Stop Gallery, Bath, U.K.
Zone Gallery, Newcastle, U.K.
1997
In a Shaded Place, The Digital and the Uncanny, British Council Milano; Bologna (Mostra itinerante/Travelling exhibition)

Mostre collettive
Group Exhibitions
1989
Fruitmarket Open, Fruitmarket Gallery, Edinburgh
1989
Scatter, Centre for Contemporary Arts, Glasgow
1993
Fine, Mall Galleries, London
M.A.Shows, Goldsmith's College, University of London, London
Exposure, Contemporary Photography from the Scottish Arts Council's Collection, Centre for Contemporary Arts, Glasgow
Public Bodies, Private States, Collins Gallery, Strathclyde University for 'Fotofeis', Glasgow

1994
Revisions - Zeitgenossische Fotographie aus Scottland, Staat Museum, München
Whitechapel Open, Whitechapel Gallery, London
1995
John Kobal Portrait Award Exhibition, National Portrait Gallery, London (Mostra itinerante/Travelling exhibition)
1996
The Pilar Juncosa and Sotheby's Photography Award, Fundaciò Pilar y Joan Miró, Palma de Mallorca, España
Future Vision, The Photographer's Gallery, London
1997
Peripherie, Darmstaadt, Deutschland
Afternoon in the Park, Laurent Delaye Gallery, London
History, Image based work in Britain in the late 20th Century, The Mag Collection, Ferens Art Gallery, Kingstone upon Hull, U.K.
Strange Days, Claudia Gian Ferrari Arte Contemporanea, Milano

Steven Pippin

Redhill (U.K.), 1960
Vive e lavora a Londra e a Berlino
He lives and works in London and Berlin

Mostre Personali
Solo Exhibitions
1993
Introspective, ICA, London
Projects 44, Museum of Modern Art, New York
1994
Migrateurs, ARC Musée d'Art Moderne de la Ville de Paris, Paris
Retrospective, A/C Project Room Enterprise, New York

Interior, Regen Projects, Los Angeles
Jack Hanley Gallery, San Francisco
Work from the Recession, Victoria Miro Gallery, London
Addendum, Portikus, Frankfurt
1995
Study in Time and Motion, F.R.A.C. Limousin, Limoges, France
Negative Perspective, Ujazdowskie Castle, CCA, Warszawa
1997
Terrestrial T.V., Gavin Brown Enterprise, New York

Mostre Collettive
Group Exhibitions
1986
New British Sculpture, Air Gallery, London
1987-88
Germinations IV, London (Mostra itinerante/Travelling exhibition)
1990
Launderama, London Film Festival, London
1991
Artist in Residence at Sculpture Space, Utica, New York
1992
Insignificant, 10 East 39th St. Suite 525, New York
Twelve British Artists, Stein Gladstone Gallery, New York
Home Improvements, 209 West 97th St., New York
1993
Max Hetzler Gallery, Köln
Aperto '93, Biennale di Venezia, Venezia
Behind Closed Doors, Milano
Wonderful Life, Lisson Gallery, London
Carlton Palace Hotel, Paris
Self Winding, Nanba City Hall, Osaka & Sphere Max, Tokio
1994
Cloaca Maxima, Museum der Stadtentwasserung, Zürich
Audience 0.01, Flash Art

Museum, Trevi, Italia
Domestic Violence, Giò Marconi, Milano
Rien à Signaler, Galerie Analix, Genève
Conceptual Living, Rhizome, Amsterdam
Minky Manky, South London Art Gallery, London
1995
Sites of Being, ICA, Boston
Brilliant! New Art from London, The Walker Art Centre, Minneapolis, USA
Kwangju Biennale, Kwangju, South Korea
Selfmade, Kunstverein, Graz, Österreich
1997
Strange Days, Claudia Gian Ferrari Arte Contemporanea, Milano

Stuart Smith

Epsom (U.K.), 1965
Vive e lavora a Londra
He lives and works in London

Mostre Personali
Solo Exhibitions
1987
Chapter Arts Centre, Cardiff, U.K.
1988
Celtic Festival, Lincolnshire, U.K.
Photographers' Workshop, Southampton, U.K.
Poetry Review Society, London
Royal Photographic Society, Bath, U.K.
1989
Gracefields Arts Centre, Dumfries, U.K.
Posterngate Photography Gallery, Hull, U.K.
St.Donats Arts Centre, Llantwit Major, U.K.
Salisbury Arts Centre, Salisbury, U.K.
F. Stop Gallery, Bath, U.K.

Quay Arts Centre, Isle of Wight, U.K.
1993
Bedford Literature Festival, Bedford, U.K.
1995
The National Literature Centre for Wales, Swansea, U.K.

Mostre Collettive
Group Exhibitions
1997
Strange Days, Claudia Gian Ferrari Arte Contemporanea, Milano

John Stezaker

Worcester (U.K.), 1949
Vive e lavora a Londra
He lives and works in London

Mostre Personali
Solo Exhibitions
1973
Museum of Modern Art, Oxford
1974
Galerie Decembre, Münster
Galleria Lia Rumma, Roma
Galleria Lia Rumma, Napoli
1975
Nigel Greenwood Gallery, London
Eric Fabre Gallery, Paris
Galleria Lia Rumma, Roma
Galleria Lia Rumma, Napoli
1976
Nigel Greenwood Gallery, London
Eric Fabre Gallery, Paris
1977
Nigel Greenwood Gallery, London
Eric Fabre Gallery, Paris
Galleria Schema, Firenze
Spectro Arts, Newcastle, U.K.
1978
The Photographer's Gallery, London
Ikon Gallery, Birmingham
1979
Eric Fabre Gallery, Paris
Kunstmuseum, Luzern
Ikon Gallery, Birmingham

New '57 Gallery, Edinburgh
1983
Lisson Gallery, London
1989
The New Work, Salama-Caro
Gallery, London
Neue Werke, Friedman-Guinness
Gallery, Frankfurt
Glenn-Dash, Los Angeles
1990
Film Still Collages, Friedman-
Guinness Gallery, Frankfurt
1991
Care&Control, Salama-Caro
Gallery, London
1996
Cubitt Gallery, London

**Mostre Collettive
Group Exhibitions
1995**
Cocaine Orgasm, Bank, London
Zombie Golf, Bank, London
Happy Squirrell Club, De
Fabrique, Rotterdam
1996
Life / Live, ARC Musée d'Art
Moderne de la Ville de Paris
(Mostra itinerante/Travelling
exhibition)
1997
Strange Days, Claudia Gian Ferrari
Arte Contemporanea, Milano

Sam Taylor-Wood

London, 1967
Vive e lavora a Londra
She lives and works in London

**Mostre personali
Solo exhibitions
1994**
Killing Time, The Showroom,
London
1995
Sam Taylor-Wood, Gallerie
Andreas Brändström, Stockholm
1995-96
Travesty of a Mockery, White

Cube, London
1996-97
Pent-Up, Chisenhale Gallery,
London
Third Floor Gallery, City Library
and Arts Centre, Sunderland, U.K.

**Mostre Collettive
Group Exhibitions
1991**
Show Hide Show, Anderson
O'Day Gallery, London
1992
Colve Two Gallery, London
1993
Wonderful Life, Lisson Gallery,
London
Lucky Kunst, Silver Place, London
Annihilation, Victoria Miro
Gallery, London
1994
Don't Look Now, Thread Waxing
Space, New York
1995
Young British Artists, Biennale di
Venezia, Venezia
Stoppage, CCC Tours, France
British Art 4, South Bank Centre,
London (Mostra itinerante/
Travelling exhibition)
Masculin Feminin, Centre
Georges Pompidou, Paris
Brilliant! New Art from London,
Walker Art Centre, Minneapolis,
USA
Perfect Speed, Toronto (Mostra
itinerante/Travelling exhibition)
Images of Masculinity, Victoria
Miro Gallery, London
1996
Contemporary British Art,
Toyama Museum, Japan
The Event Horizon, The Irish
Museum of Modern Art, Dublin
Life / Live, ARC Musée d'Art
Moderne de la Ville de Paris, Paris
(Mostra itinerante / Travelling
exhibition)
Other Men's Flowers, Aurel
Scheibler, Köln
Full House, Kunstmuseum,

Wolfsburg, Deutschland
Manifesta 1, Museum Boymans-
van Beuningen, Rotterdam
Porspect '96, Kunstverein,
Frankfurt
*Some of My Best Friends are
Geniuses*, IAS, London
*Festival of Contemporary British
Arts*, Magazzini d'Arte Moderna,
Roma
Image of Self as Another,
Taidemuseo, Pori, Finland
1997
Strange Days, Claudia Gian
Ferrari Arte Contemporanea,
Milano

Gillian Wearing

Birmingham (U.K.), 1963
Vive e lavora a Londra
She lives and works in London

**Mostre Personali
Solo Exhibitions
1993**
City Racing, London
1994
Interim Art, London
1995
Western Security, Hayward
Gallery, London
1996
Wish You Were Here, Video
Evenings at De Appel, De Appel,
Amsterdam
Le Consortium, Dijon, France
*Gillian Wearing, City Projects -
Prague Part II*, The British
Council, Praha
Interim Art, London
1996-97
Interim Art, London
1997
Chisenhale Gallery, London
Jay Gorney Modern Art, New York
Kunsthaus Zurich, Zürich
Gillian Wearing / Barbara Visser,
Bloom Gallery, Amsterdam
Galleria Emi Fontana, Milano

Mostre Collettive
Group Exhibitions

1991
Empty Gestures, Diorama Art Centre, London
1993
BT Young Contemporaries, Cornerhouse, Manchester, (Mostra itinerante/Travelling exhibition)
1994
Domestic Violence, Giò Marconi, Milano
1995
X/Y, Centre Georges Pompidou, Paris
It's Not a Picture, Galleria Emi Fontana, Milano
Brilliant! New Art from London, Walker Arts Center, Minneapolis
Campo, Biennale di Venezia, Venezia
1996
Life/Live, ARC Musée d'Art Moderne de la Ville de Paris, Paris (Mostra itinerante/Travelling exhibition)
Toyama Now '96, Museum of Modern Art, Toyama, Japan
Now Here, Lousiana Museum, Humlebaek, Danmark
1997
Strange Days, Claudia Gian Ferrari Arte Contemporanea, Milano

Catherine Yass

London, 1963
Vive e lavora a Londra
She lives and works in London.

Mostre Personali
Solo Exhibitions
1991
Tavistock Clinic, London
1992
Laure Genillard Gallery, London
1994
Chair, Viewpoint Gallery, Salford

Heber Percy Gallery, Leamington Spa, U.K.
1995
Spectators, Aspex Gallery, Portsmouth, U.K.
1996
Stall, Laure Genillard Gallery, London
Steel, Fotogallery, Cardiff, U.K. (Mostra itinerante/Travelling exhibition)
1997
Cell, Barbican Centre, London
Grave, Portfolio Gallery, Edinburgh

Mostre Collettive
Group Exhibitions
1984
New Contemporaries, ICA, London
1985
Ackerstrasse Gallery, Berlin
1989
Suppose It's True After All?, Crypt Gallery, London
1990
Countdown, Chisenhale Gallery, London
Swimming Underwater, Imagination Building, London
Post-morality, Cambridge Darkroom, Cambridge, U.K.
Madonnas, Diorama Gallery, London
1991
Clove Building, Butler's Wharf, London
Times Young Artists, London Contemporary Art Fair, London
Signs of the Times, Camerawork, London
1992
Anomie, Patent House, London
1993
Vox Pop, Laure Genillard Gallery, London
1994
Whitechapel Open, Whitechapel Art Gallery, London
Laure Genillard Gallery, London

1995
Institute of Cultural Anxiety: Works from the Collection, ICA, London
The British Art Show, Manchester (Mostra itinerante/Travelling exhibition)
1996
Take It from Here, Sunderland Museum and Art Gallery, Sunderland, U.K.
Manifesta 1, Rotterdam
1997
Light, Richard Salmon, London
Commissioned Portrait of Denys Lasdun, Royal Academy of Arts, London
Six Unrelated Projects, The Tannery, London
Urban Legends-London, Staatliche Kunsthalle, Baden-Baden
Strange Days, Claudia Gian Ferrari Arte Contemporanea, Milano

Finito di stampare nel settembre del 1997
da Leva spa, Sesto San Giovanni
per conto di Edizioni Charta